Witchcraft Coloring Book

Witchcraft Coloring Book

Christina Haberkern

PLUME

PLUME

An imprint of Penguin Random House LLC
penguinrandomhouse.com

PLUME and P colophon are registered trademarks of
Penguin Random House LLC.

LIBRARY OF CONGRESS CATALOGING-IN-PUBLICATION DATA
has been applied for.

ISBN 9780593472545 (paperback)

Printed in the United States of America
1st Printing

COLORING TIPS

✦ This book is meant for all ages and skill levels!
Use crayons, markers, gel pens, or whatever you have!
Don't be afraid to mix your materials.

✦ There are no rules! Don't be afraid to color outside
the lines or use every color of the rainbow.

✦ Use the test page in the back of the book to test the
colors of your markers or gel pens.

✦ When coloring with a marker, place a piece of
thick paper under it to prevent the color from bleeding
through to the next page.

Most important:
Have FUN!

Marie Laveau was known as the Queen of Voodoo and lived in New Orleans from 1801 to 1881. Her dedication as a healer, herbalist, and practitioner of Voodoo commanded great respect and a massive following in the streets of New Orleans. Little is known of her life, but her legend and legacy live on in the lore that surrounds her. Marie Laveau was later portrayed by Angela Bassett in the television show *American Horror Story: Coven.*

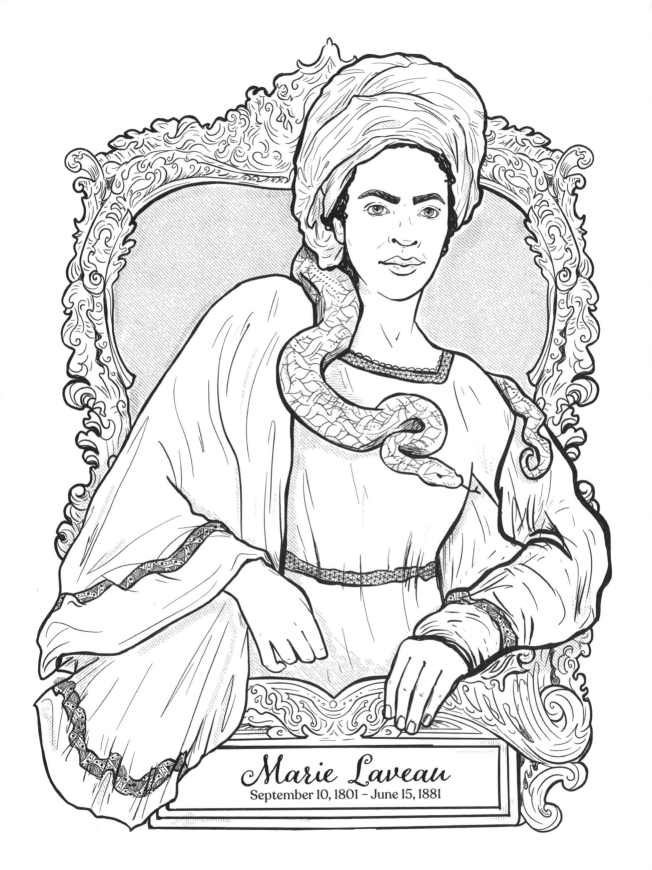

Marie Laveau

September 10, 1801 – June 15, 1881

The Sanderson sisters are a comedic trio of witches in the 1993 film *Hocus Pocus*. The film follows a teenage boy who awakens the trio inadvertently by using a spell during a full moon on All Hallows' Eve. With a recharged mission, the witches continue their plot to steal the souls of the children of Salem.

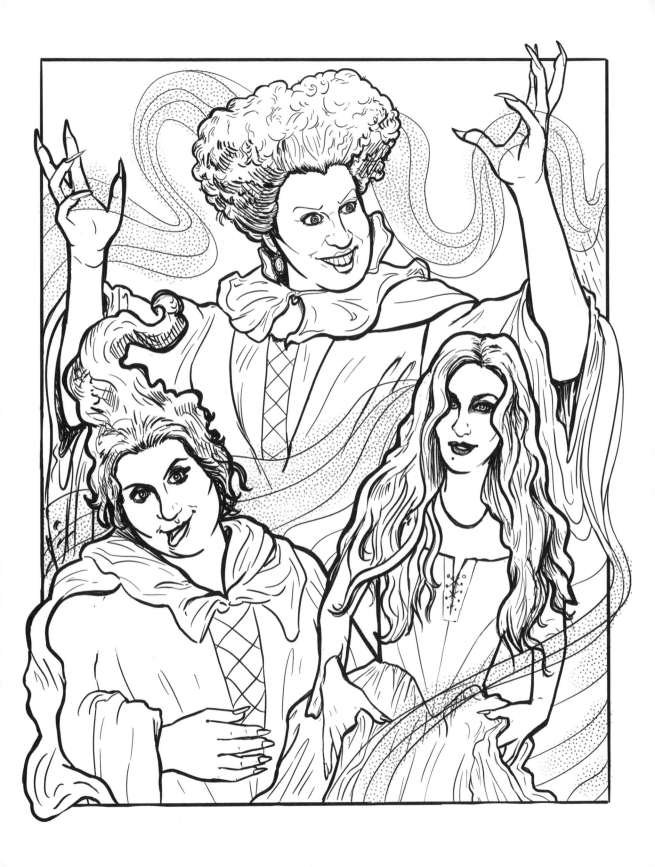

The Ouija board, also known as a spirit board or talking board, is a device used for obtaining messages from the spirit world. It uses a planchette, a wooden or plastic tool that slides to point out letters or words when pressed lightly by the participants.

Catherine Monvoisin, known as La Voisin, was a fortune-teller who lived in France in the mid-1600s. She practiced medicine, mixed potions and poisons, and was a primary figure in the *affaire des poisons*, a scandal surrounding a network of fortune-tellers that poisoned many members of the French aristocracy and was suspected to have killed over 1,000 people.

After being convicted of witchcraft in 1680, she was burned publicly.

La Voisin

mid-1600s

Witchcraft was hung, in History, But History and I, Find all the Witchcraft that we need, Around us, every Day

-Emily Dickinson

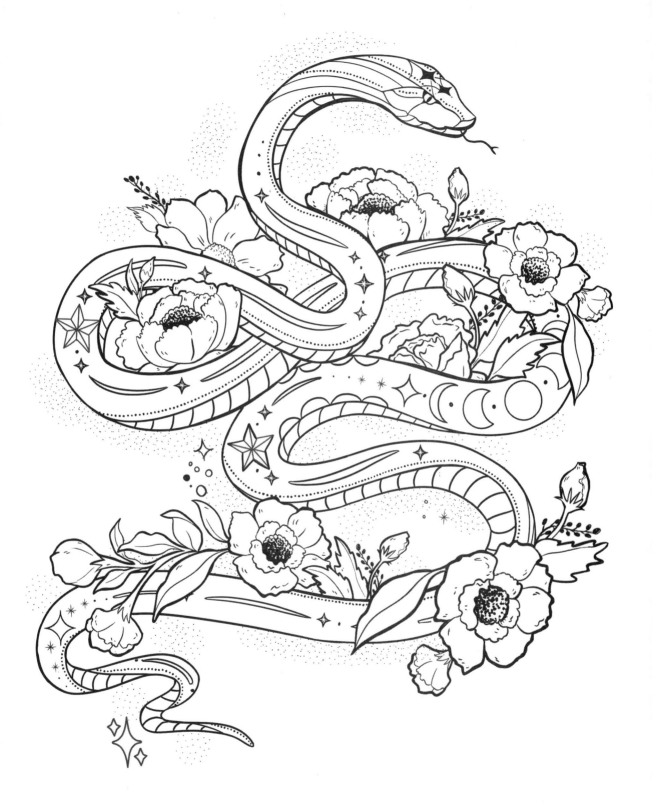

In the television series *Buffy the Vampire Slayer,* Willow Rosenberg is the best friend of the titular slayer. Transforming from a shy, normal student in Sunnydale, Willow becomes a powerful witch who struggles with her significant and growing magical abilities.

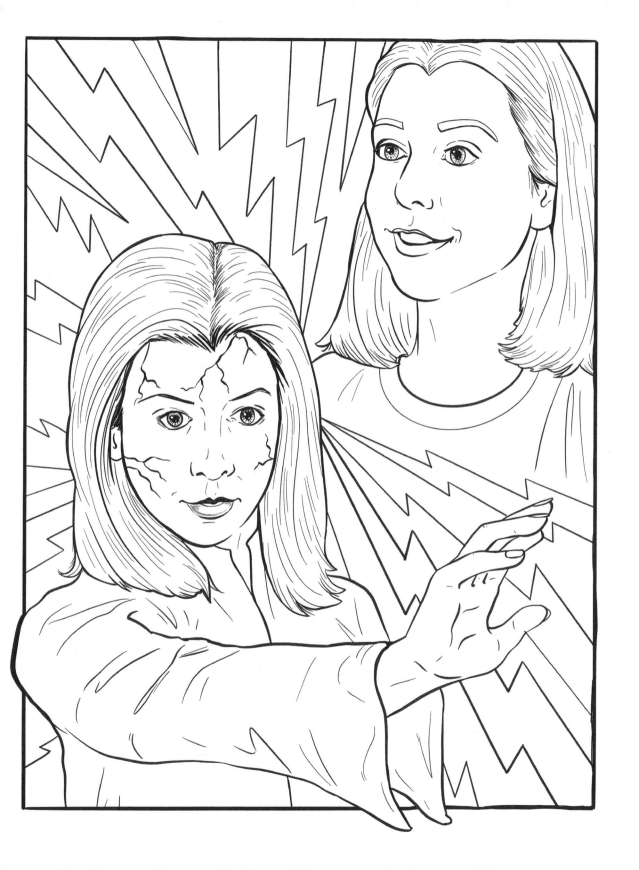

Moll Dyer was a supposed resident of Leonardtown, Maryland, and her story has become more lore than recorded fact. It is believed that in the seventeenth century, she was accused of witchcraft by a group of locals who chased her from her home on a cold winter night. Her body was found days later, frozen to a large stone. The legend of Moll Dyer eventually became the inspiration for the film *The Blair Witch Project*.

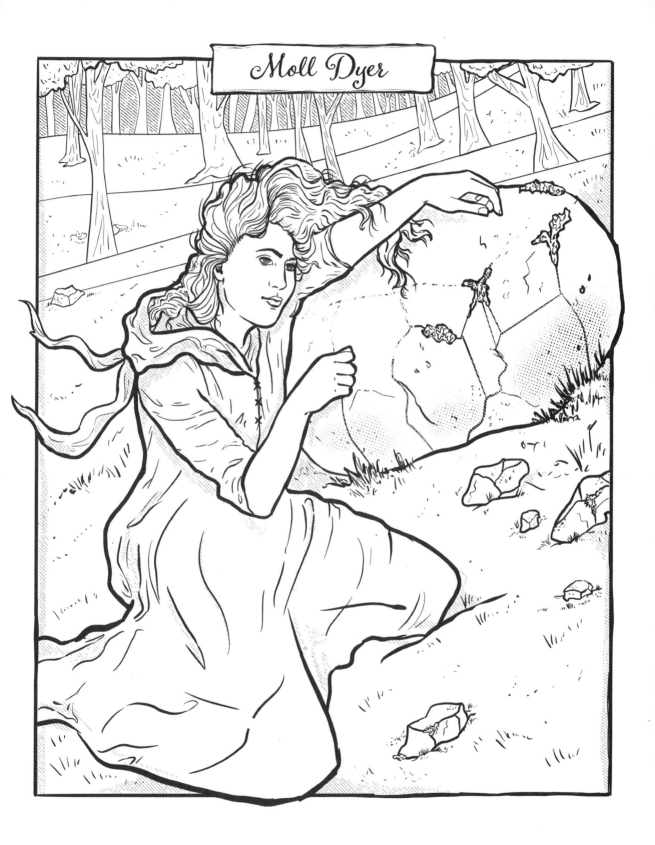

In the Harry Potter series, Professor Minerva McGonagall is a powerful witch and professor at Hogwarts School of Witchcraft and Wizardry. She is skilled in many forms of magic, including spell-casting and transfiguration, whereby she is able to transform into a tabby cat. Portrayed by the iconic actress Maggie Smith, McGonagall has a stern exterior with a strict penchant for following the rules. Underneath, it is evident that she strongly cares for her friends and students.

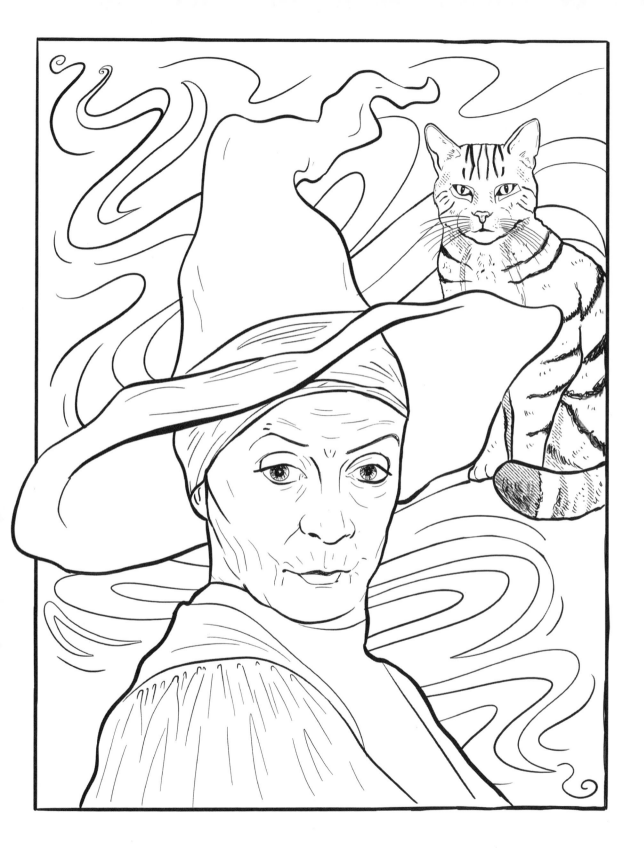

Morgan le Fey was a powerful enchantress of Arthurian legend. She was an apprentice of Merlin, a mythical figure featured in the legend of King Arthur.

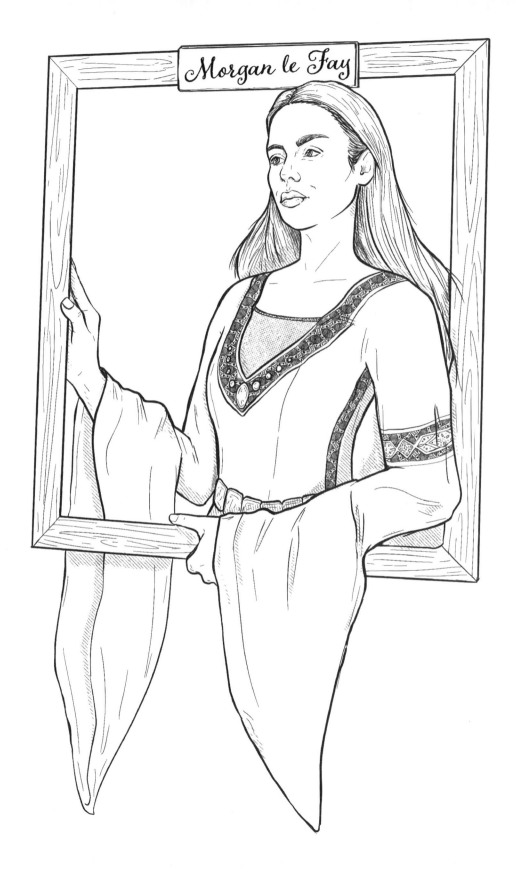

Double, double double toil and trouble; Fire burn, and caldron bubble.

-Shakespeare

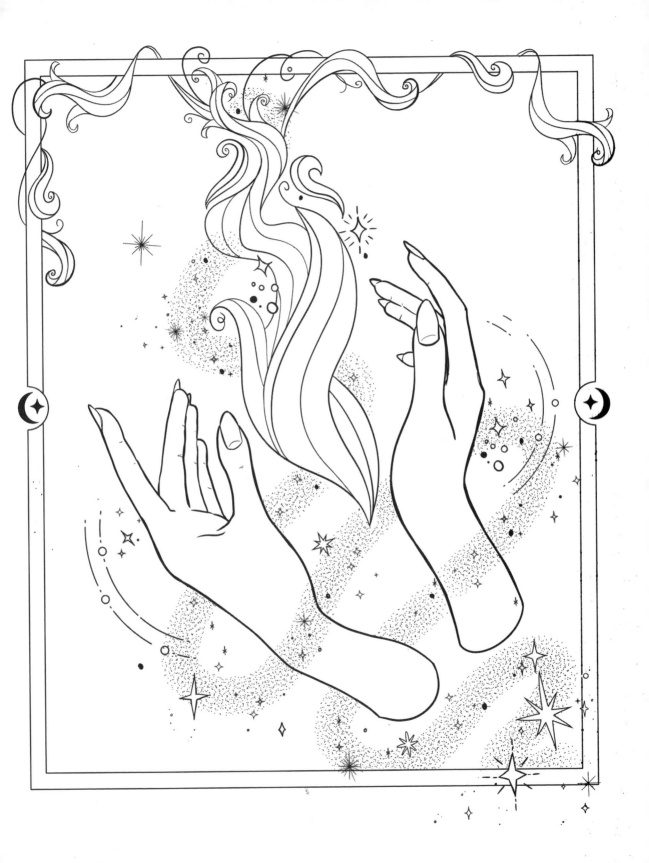

In the film *The Craft*, we follow a group of friends who join together to practice witchcraft and harness their unique abilities. After forming a coven with her fellow witches, Nancy's appetite for power leads her down a dark and dangerous path.

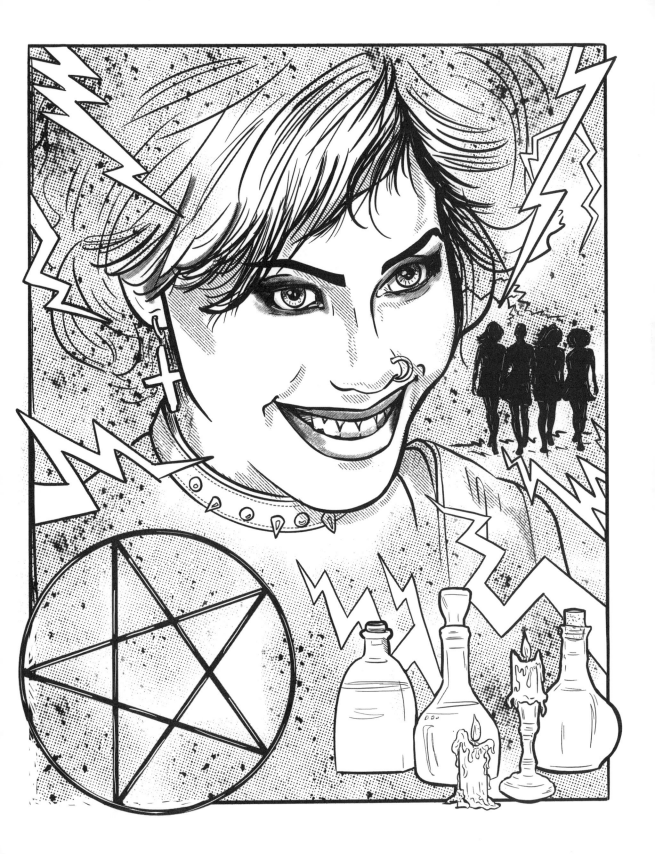

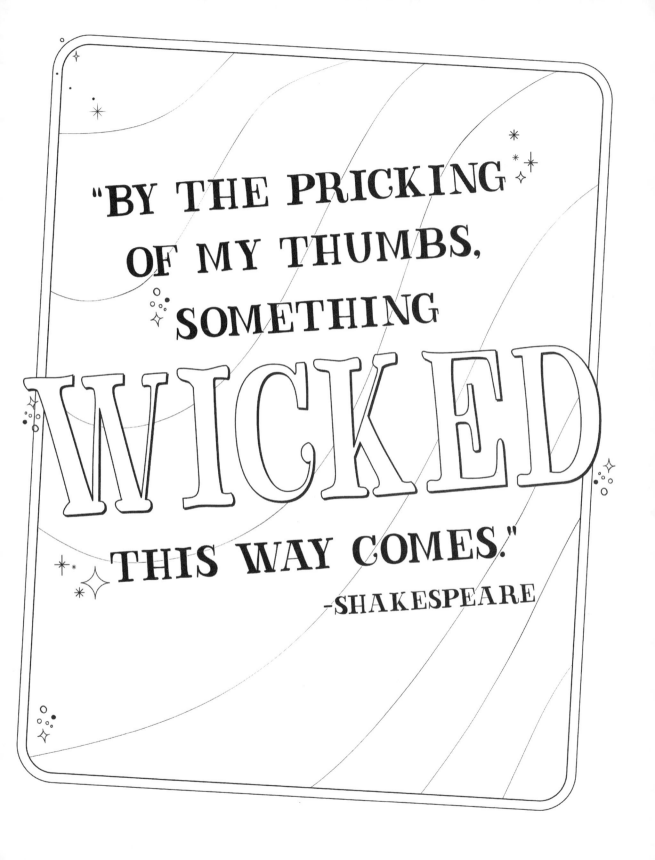

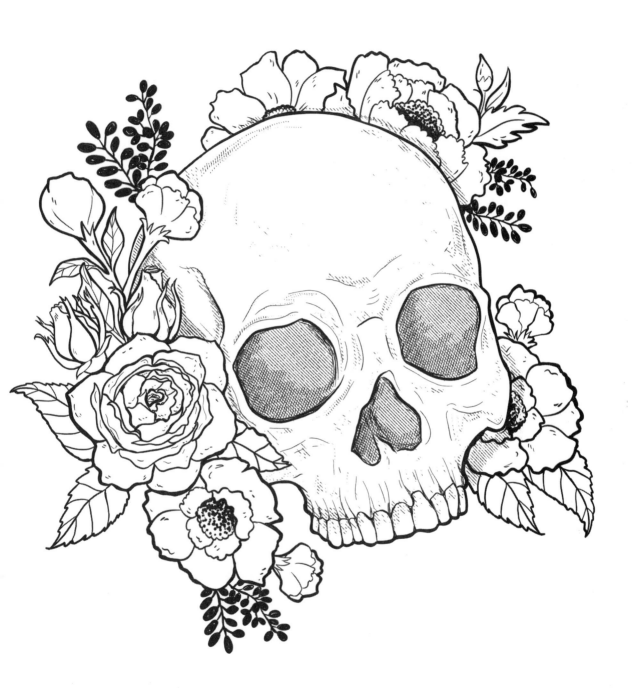

In the film *The Witches*, a young boy finds himself surrounded by witches at a convention and must stop their plot to wipe out all of England's children, even after he is magically transformed into a mouse. The title of the Grand High Witch of All the World is given to Eva Ernst, an evil witch who hides her true appearance behind a glamorous disguise in order to blend in with society.

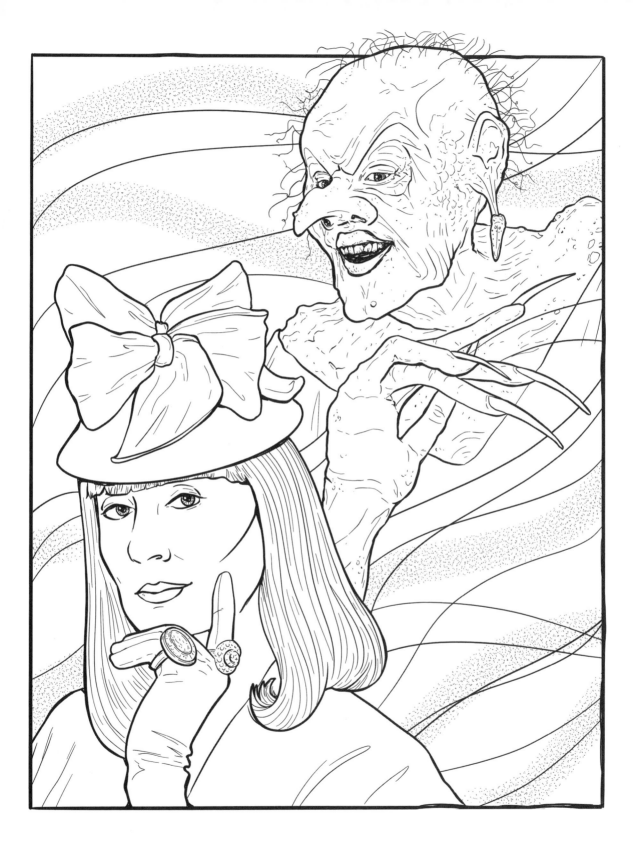

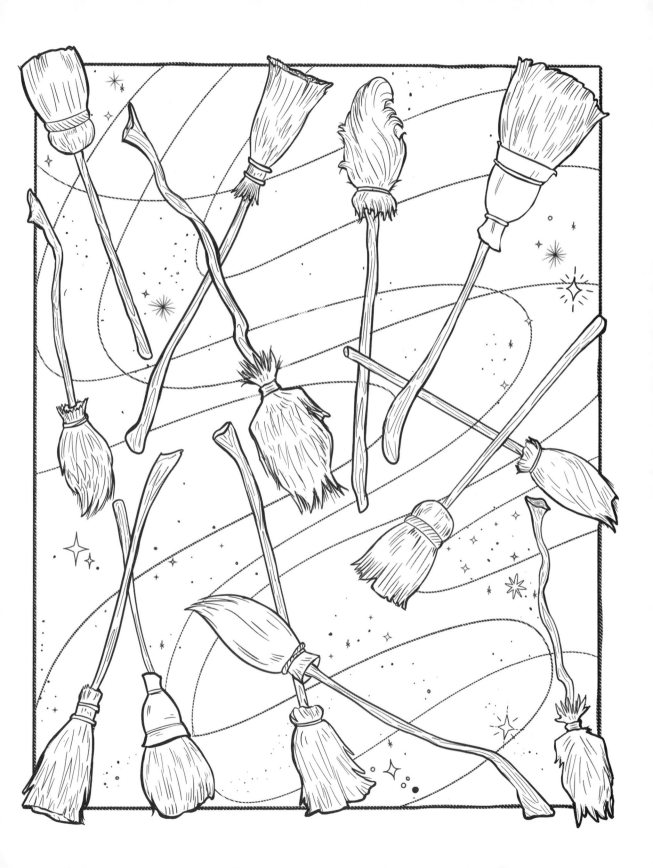

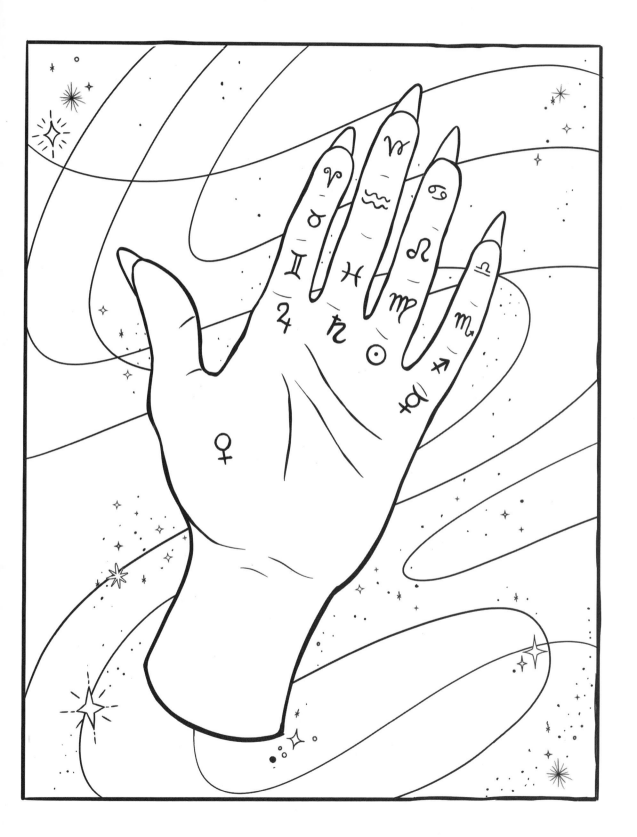

Ursula Southeil, known as Mother Shipton, was a legendary English soothsayer and prophetess. Her prophecies were published eighty years after her death and purportedly predicted such events as the Great Plague of London, the Spanish Armada, and even the Internet.

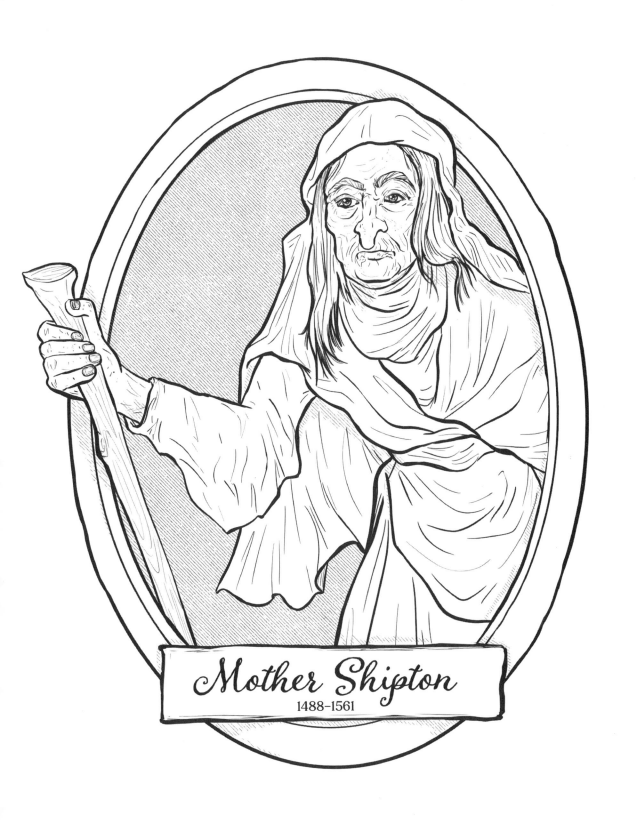

Mother Shipton

1488–1561

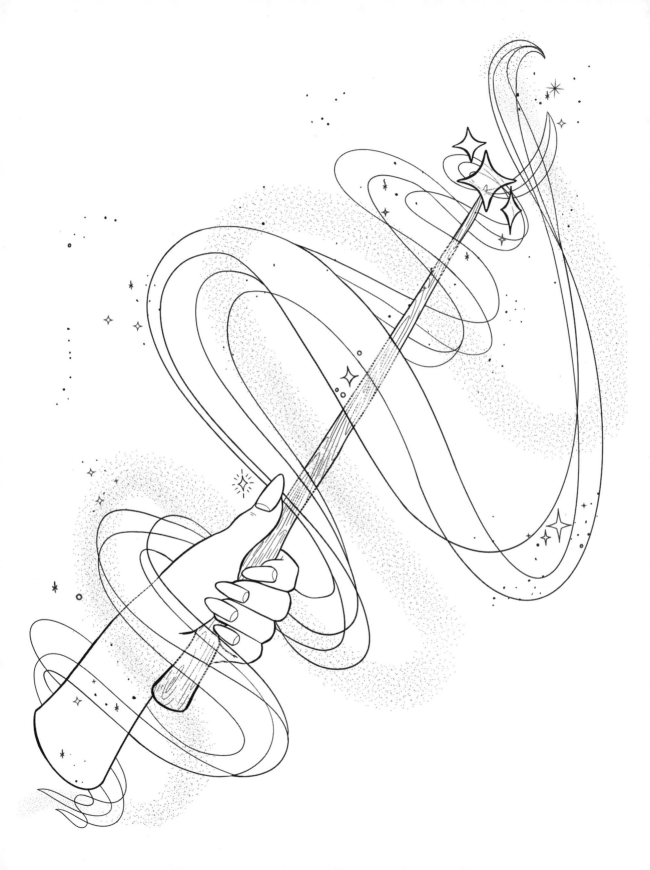

DECIDE YOUR DESTINY

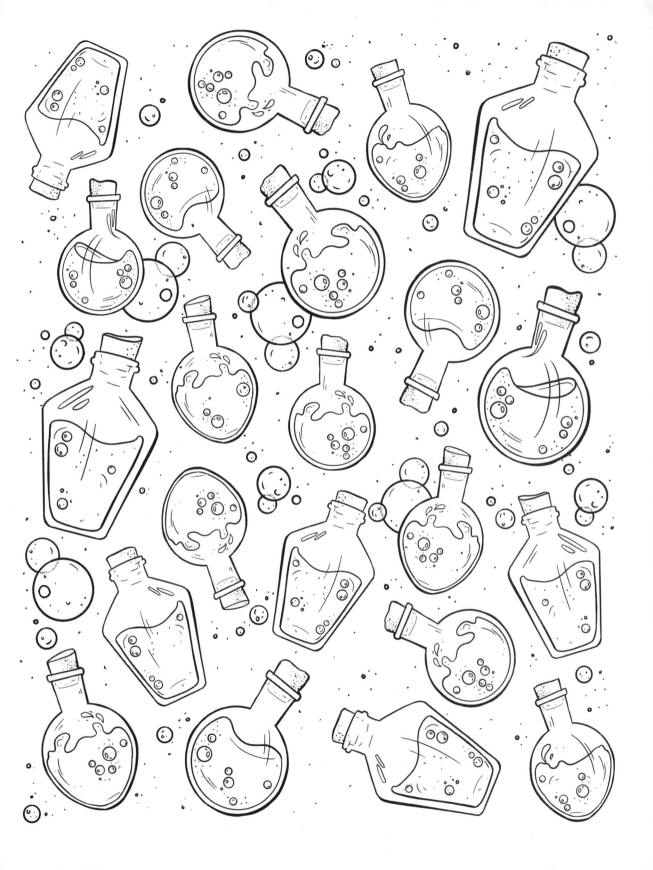

Tituba was brought to the American colonies as a slave, though her origins are debated. During the 1692 Salem witch trials, she was the first person accused of witchcraft. After being broken down, she confessed and was imprisoned for thirteen months, though she managed to escape execution by hanging for witchcraft.

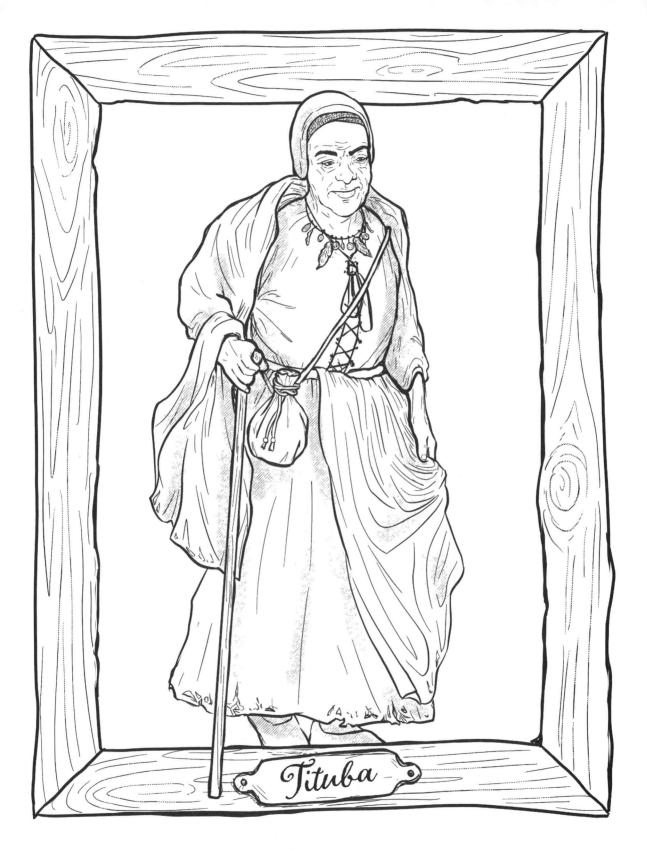

Tituba

In the film *The Wizard of Oz*, we follow the fanciful journey of a young girl named Dorothy, who dreams of a world "somewhere over the rainbow." After she is transported to the magical land of Oz during a tornado, her adventures lead her to encounter two witches, Glinda the Good Witch and the Wicked Witch of the West. The Wicked Witch of the West, with her green nose, signature black pointed hat, and menacing cackle, is one of the most iconic witches in film history.

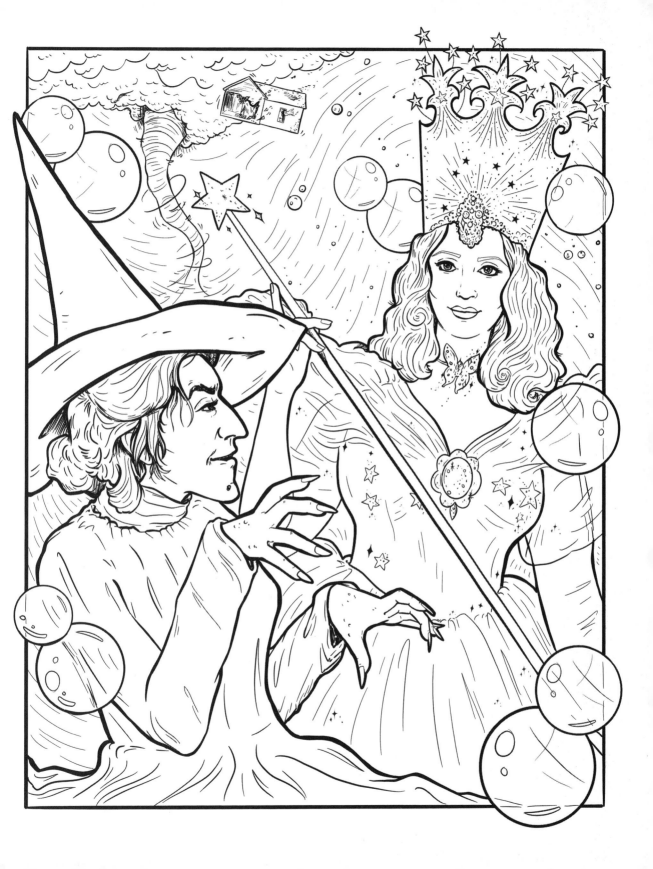

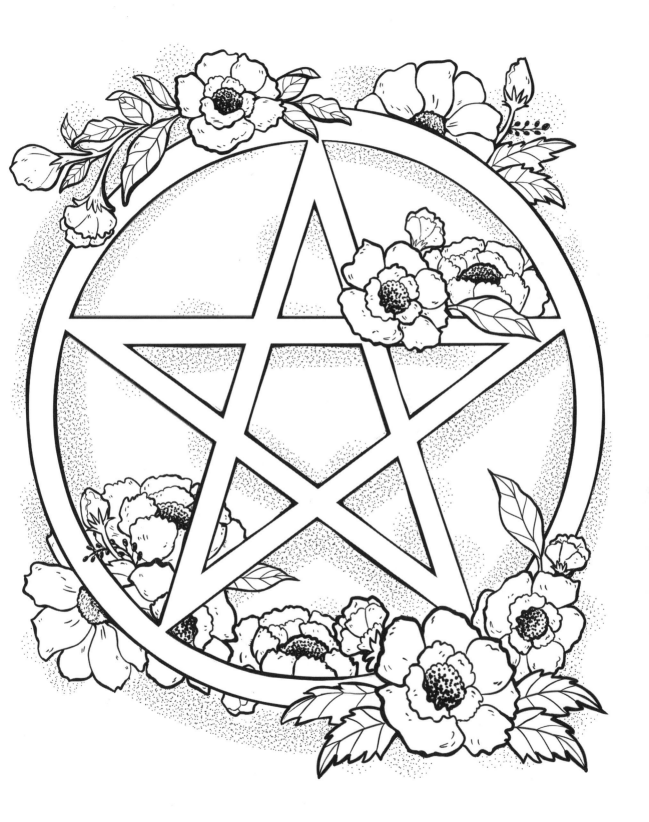

About the Author

Christina Haberkern is a designer and illustrator in Los Angeles. She is the owner and creative mind behind Hello Harlot, a stationery and gift-item brand specializing in pop culture and humorous products. Her other coloring books include *Coloring the Zodiac* and *Totally '90s Coloring Book*.

MUSIC FOR CHOIR AND CELLO

CELLO PART

EDITED BY
BECKY McGLADE

To a Skylark and *The Oak* appear here in reverse order to the anthology in order to accommodate page turns.

OXFORD
UNIVERSITY PRESS

CELLO

A Birthday

Christina Rossetti
(1830–94)

BECKY McGLADE
(b. 1974)

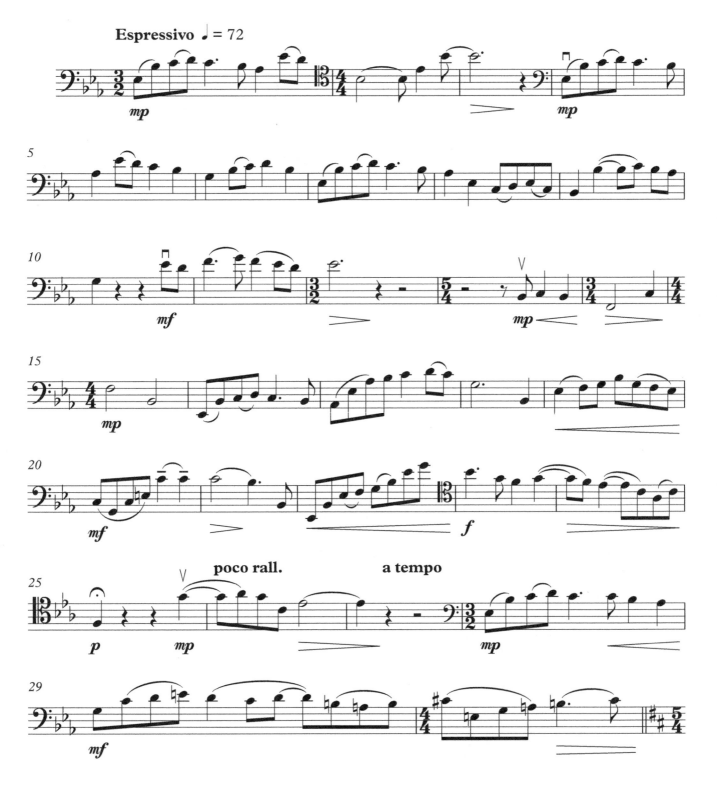

Duration: 4 mins

OXFORD UNIVERSITY PRESS, MUSIC DEPARTMENT, GREAT CLARENDON STREET, OXFORD OX2 6DP